© 2010 BY JOEDOLANPR PUBLISHING

All rights reserved. No part of this publication may be reproduced, stored in a retrieval system or transmitted in any form or by any means, electronic, mechanical, photocopying, recording, scanning or otherwise without permission from JoeDolanPR.

For general information or distribution, please contact the publisher directly by visiting: www.joedolanpr.com.

					÷			
2.								

							က်
							-

			a					
	41							
0								
б.								

			*			-	
10.							

			2				
12.							

14.							

			-				
		*					

16.

18.			

20.							

								23.
							0	
			8					
				*				

					5.			
26.								

28.				

		7						
					,			
				7				
30.								

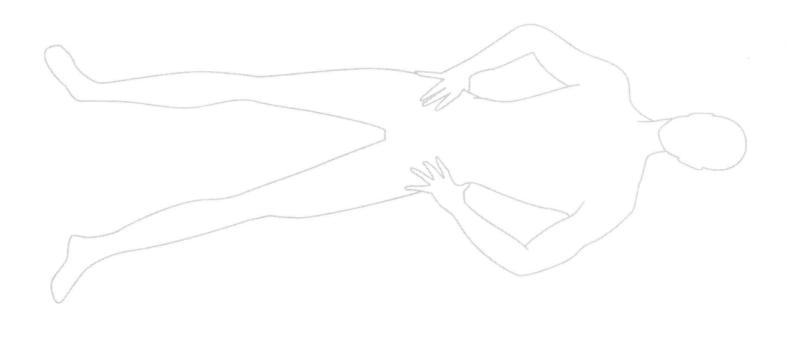

32.							

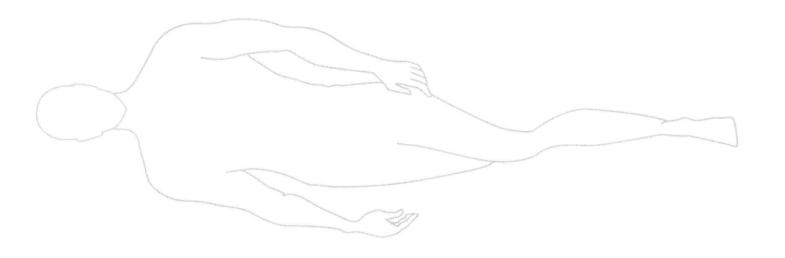

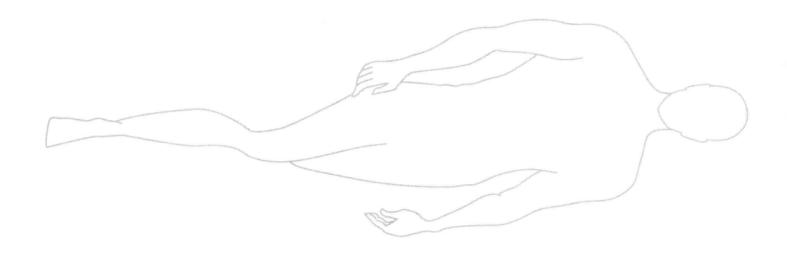

34.							

36.							

							37.
			2				

*							
			2				
38.							

				in the second			

40.

_													
42.	l	I	I	l	I	I	I	l ,	I	I	I	I	

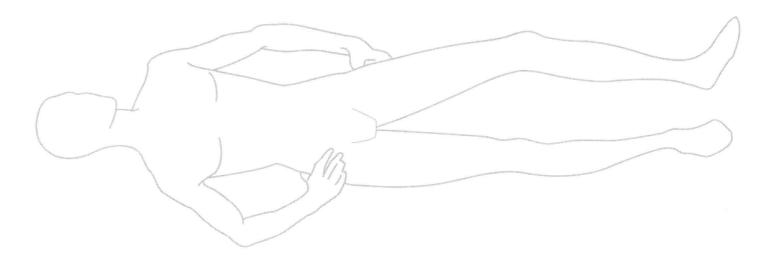

			,					
							-	
46.								

20940314R10028

Made in the USA Lexington, KY 23 February 2013